Kaleidoscopes

Book One

A Welcome Relief Adult Coloring Book

By C. H. Rains

Introduction

Welcome to A Welcome Relief Adult Coloring. Coloring has proven to be a great source of relaxation for adults in this stressed-out world. The Kaleidoscopes coloring book series opens a world of discovery for the adult coloring enthusiast. Color your way into a peaceful mood any time the world gets to be too much; or any time you need a little color in your day.

I am C.H. Rains. I have always loved to color. As an adult I found coloring to be quite therapeutic and relaxing. The act of selecting my own color scheme and completing a design image helps to bring peace and order back to mind. I keep coloring books in my house at all times. I like colored pencils and crayons best. However, you can use whatever brings you the most joy; from pencils, pastels, and paints to chalk and markers. The possibilities are as creative as your imagination.

Enjoy!

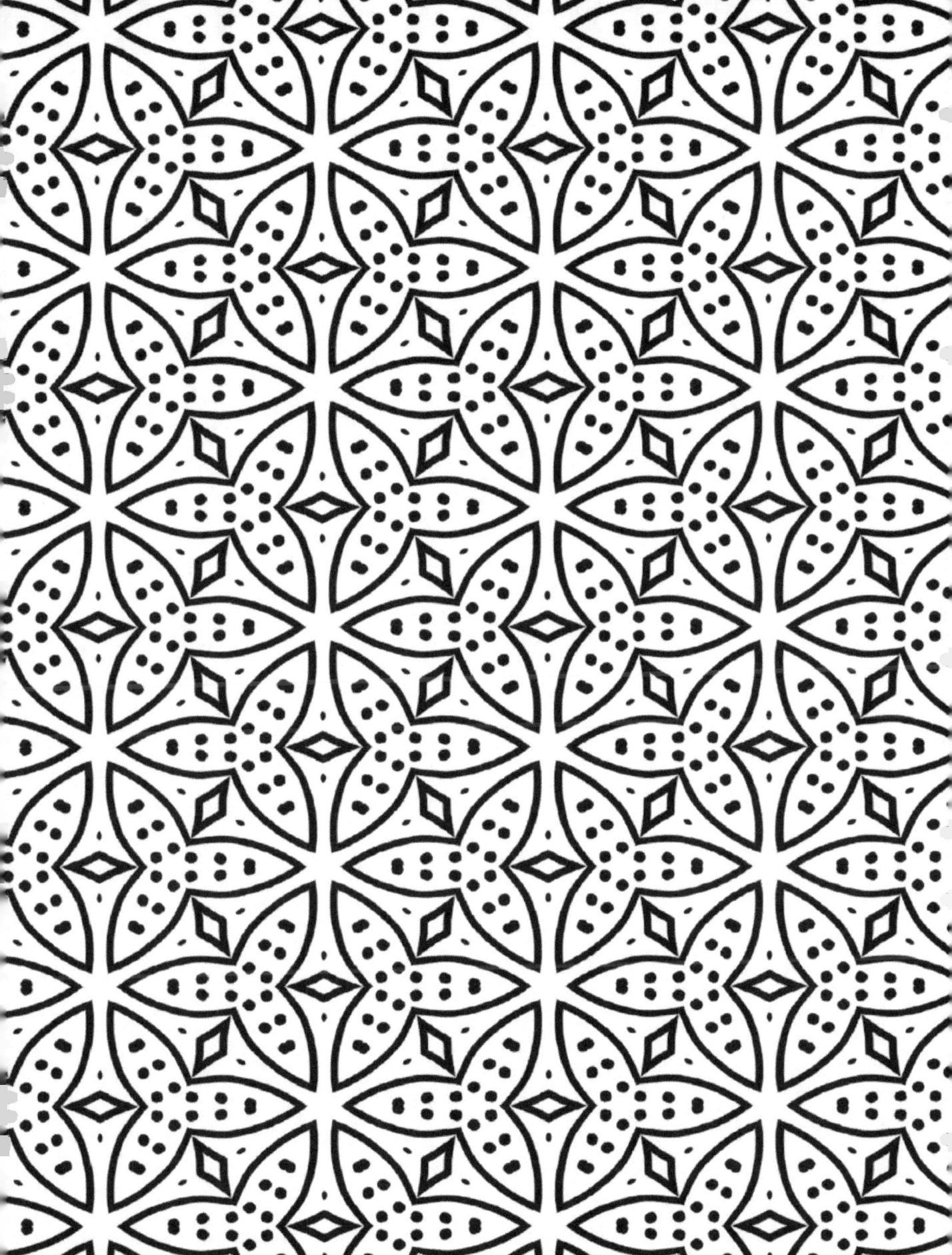

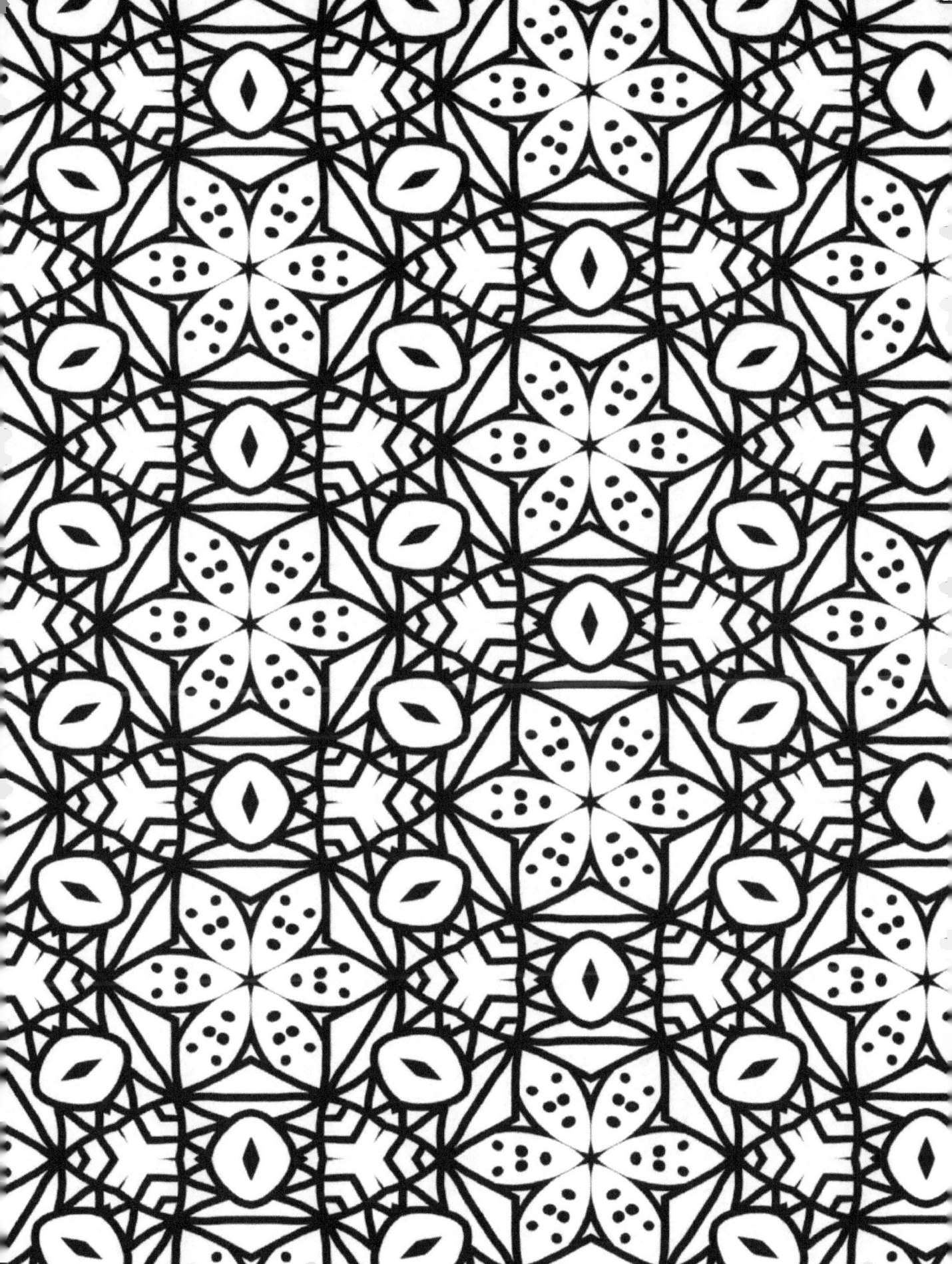

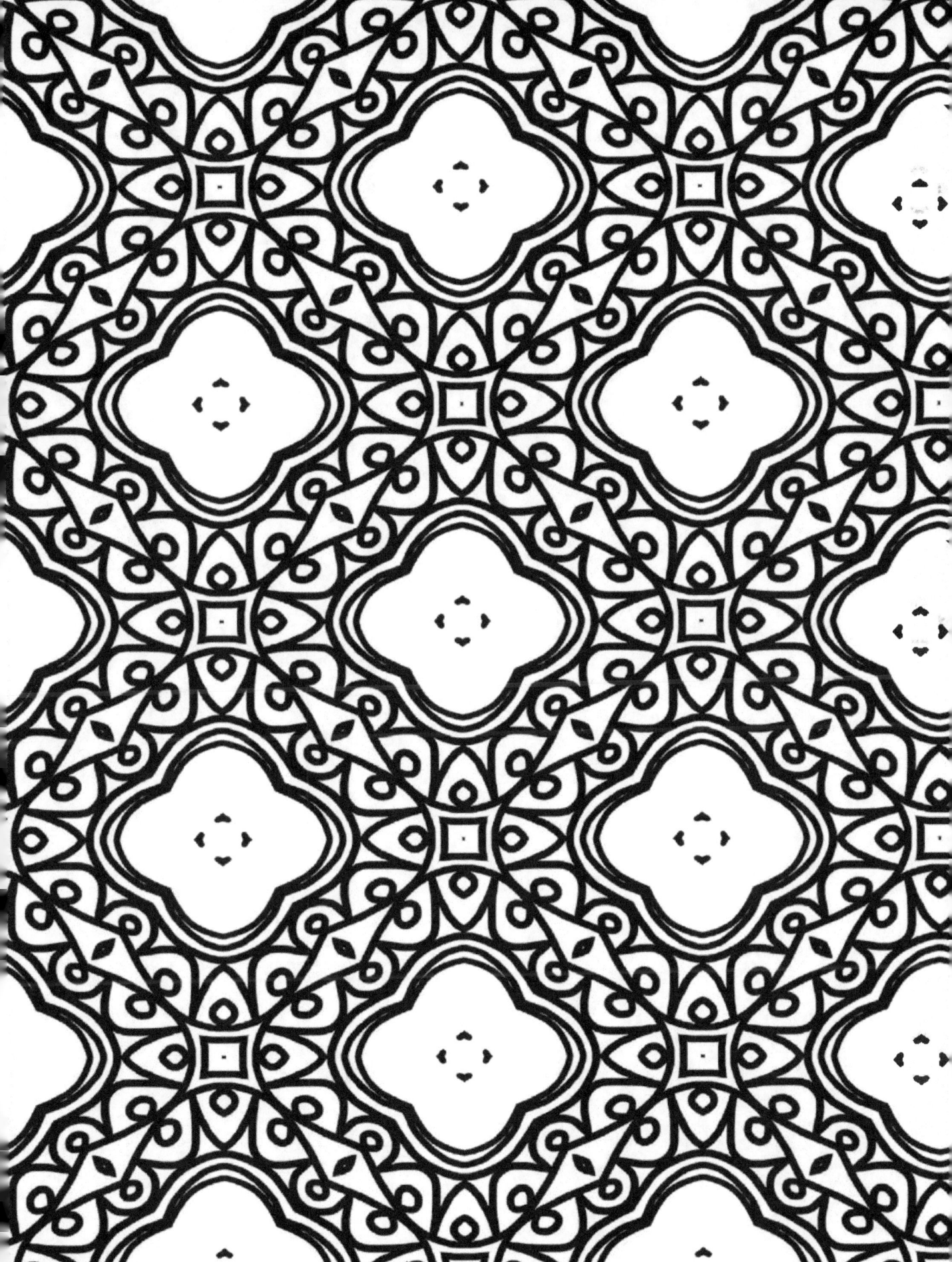

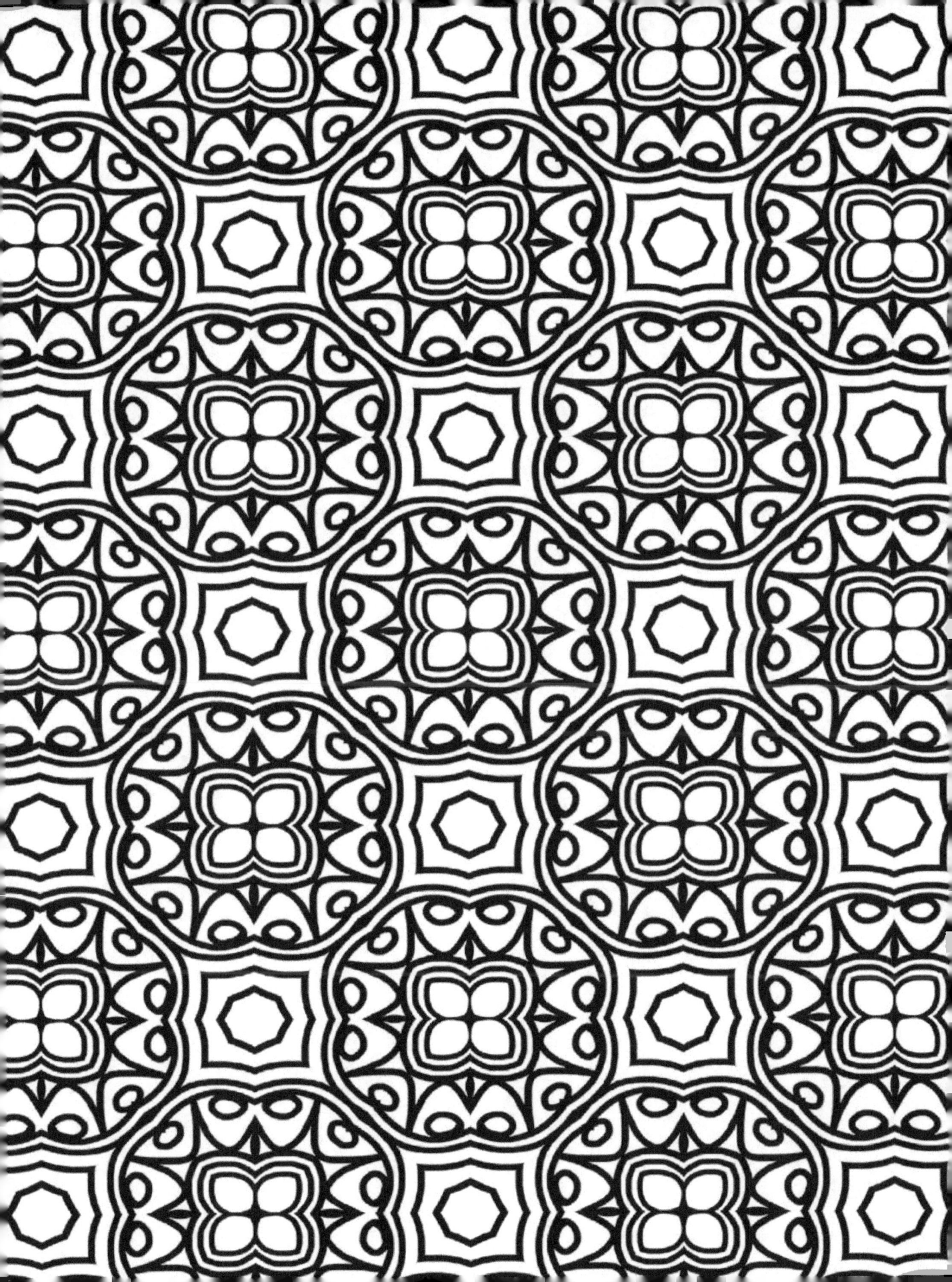

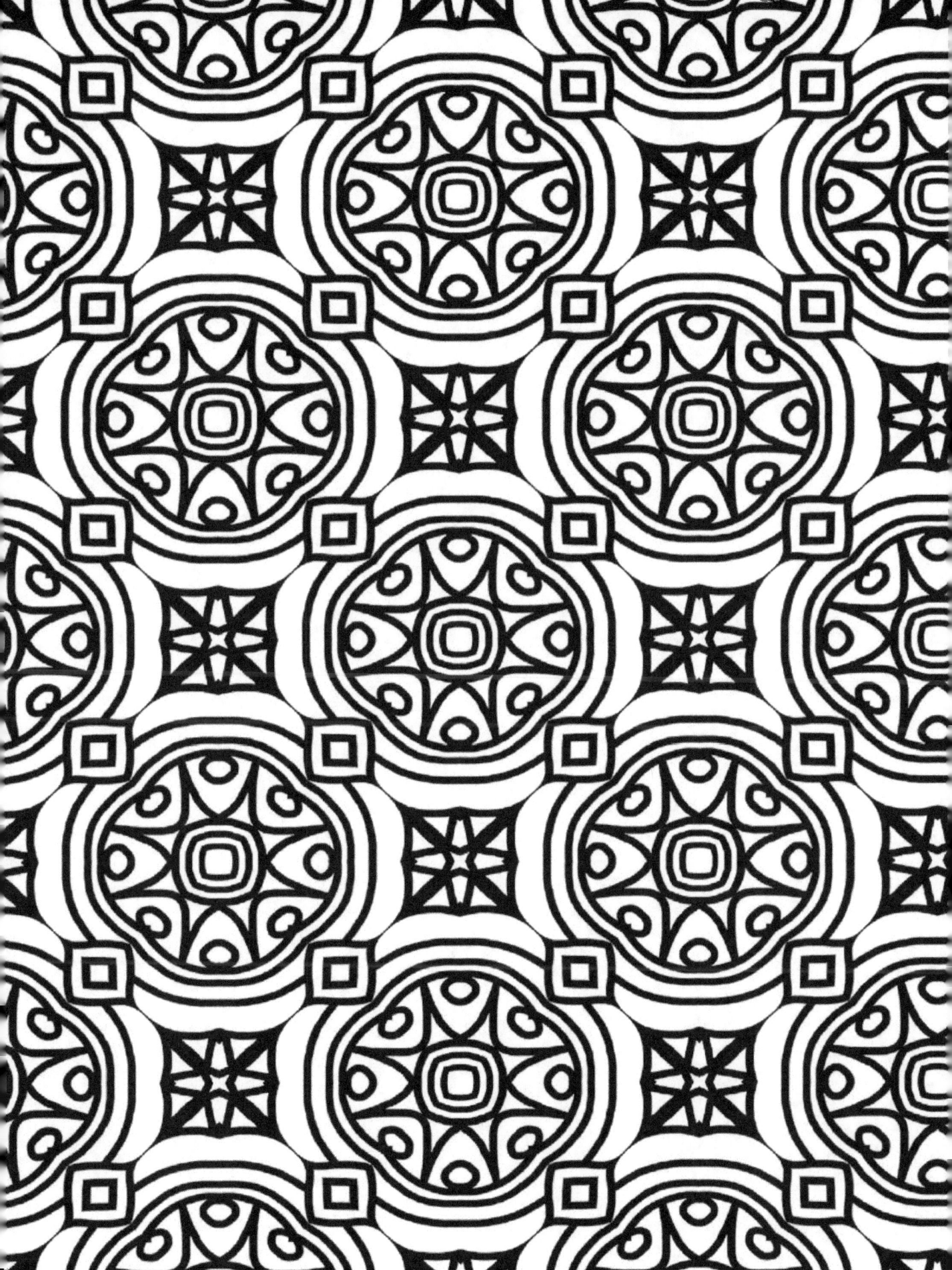

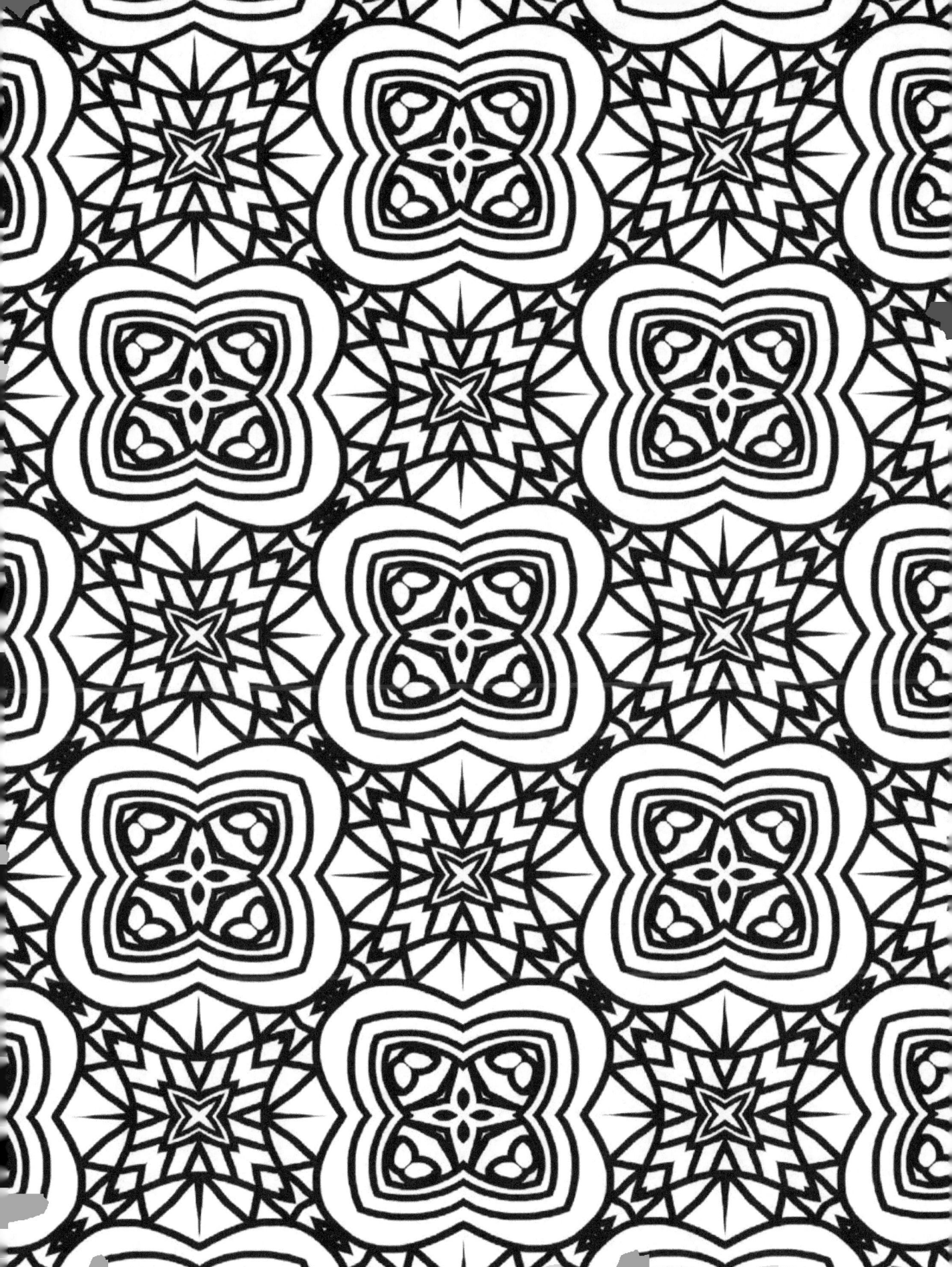

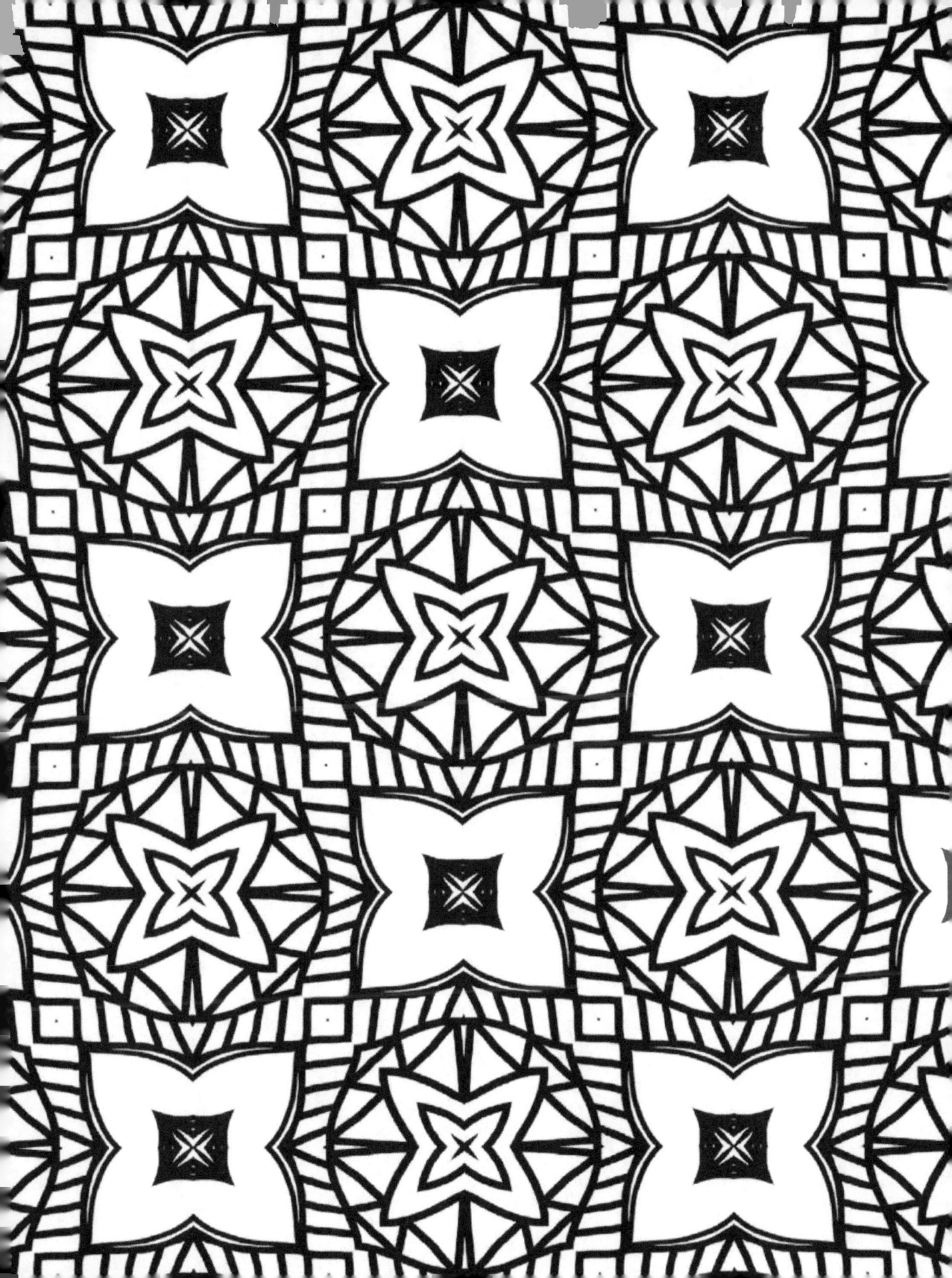

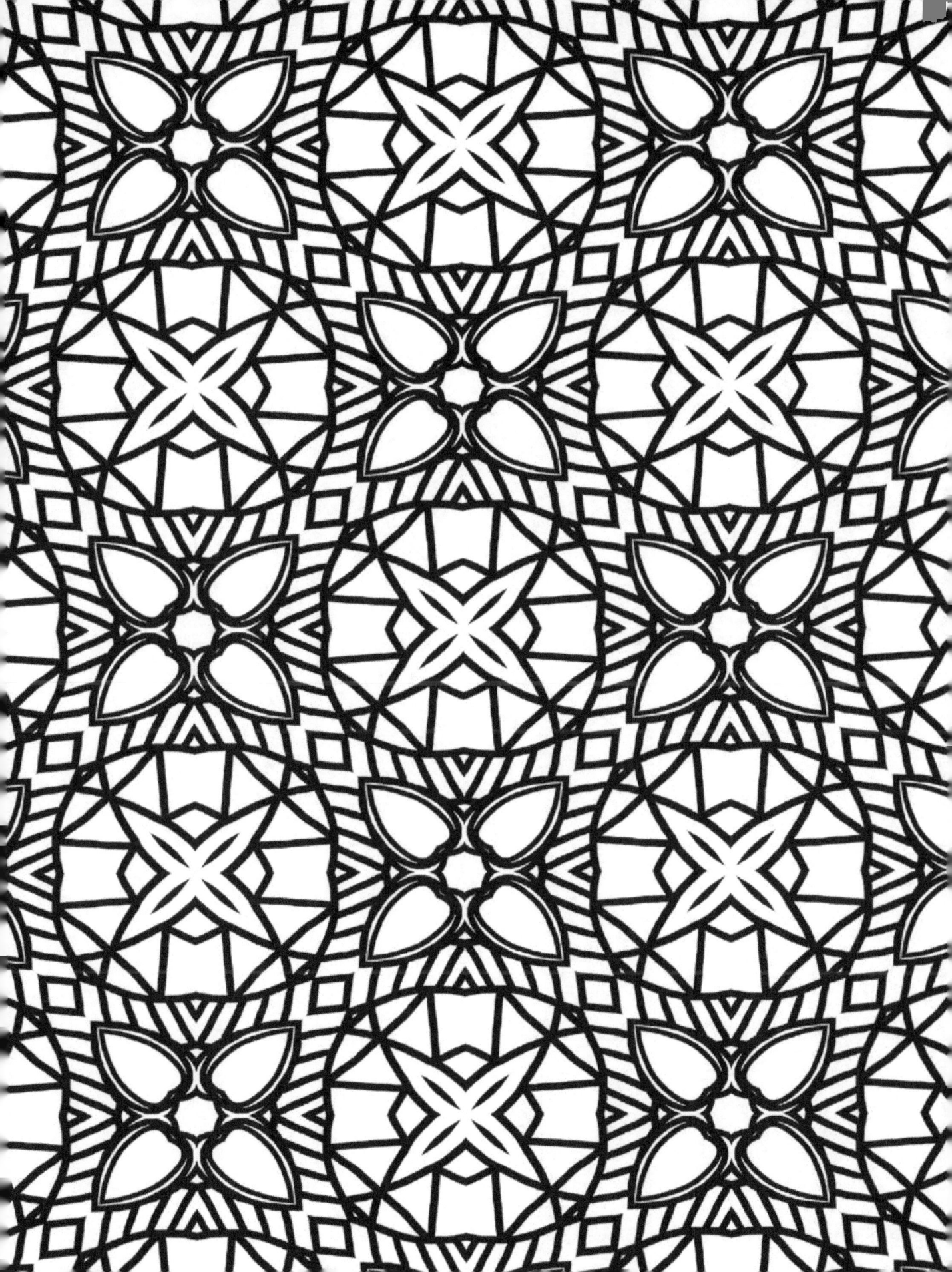

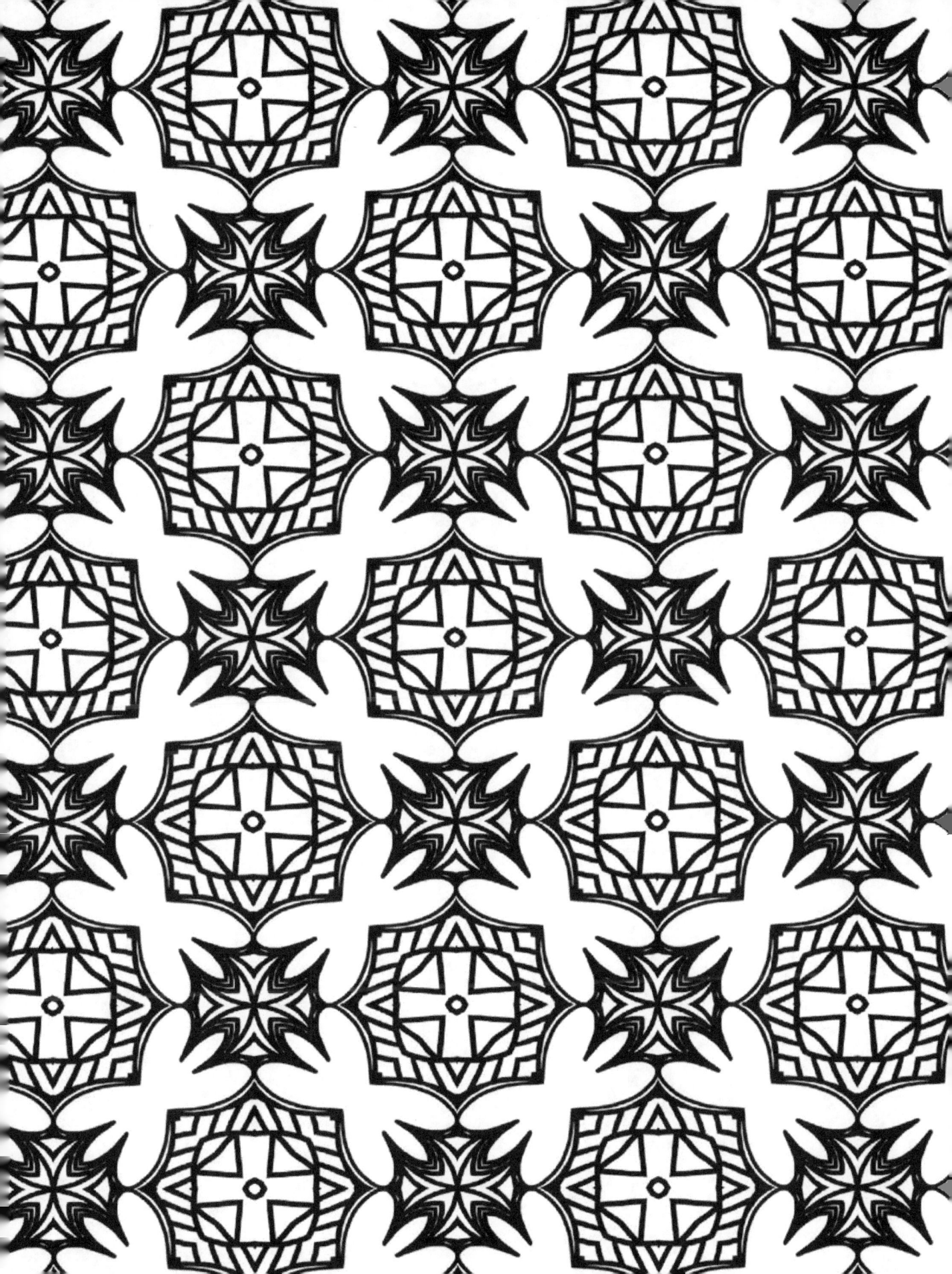

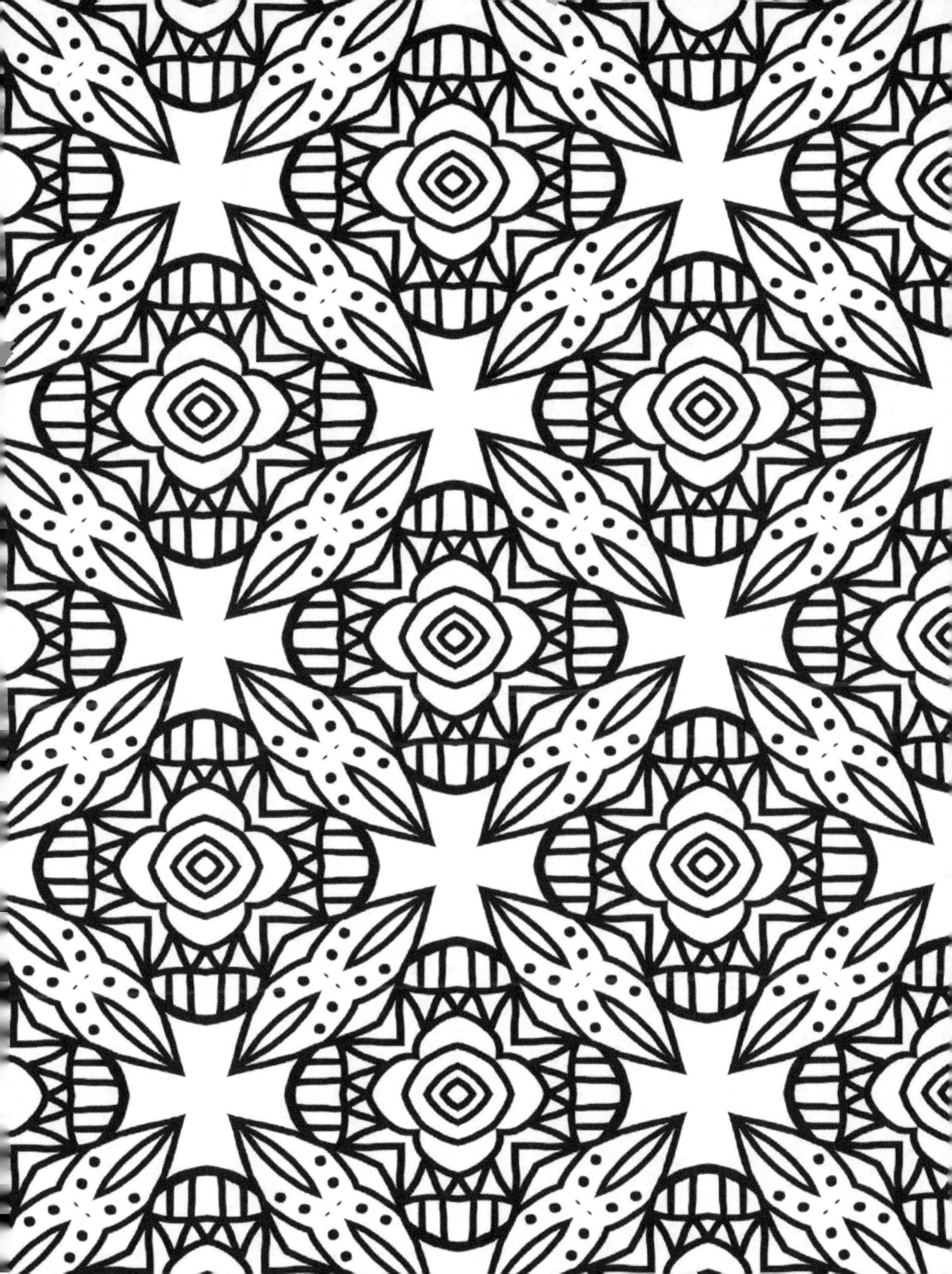

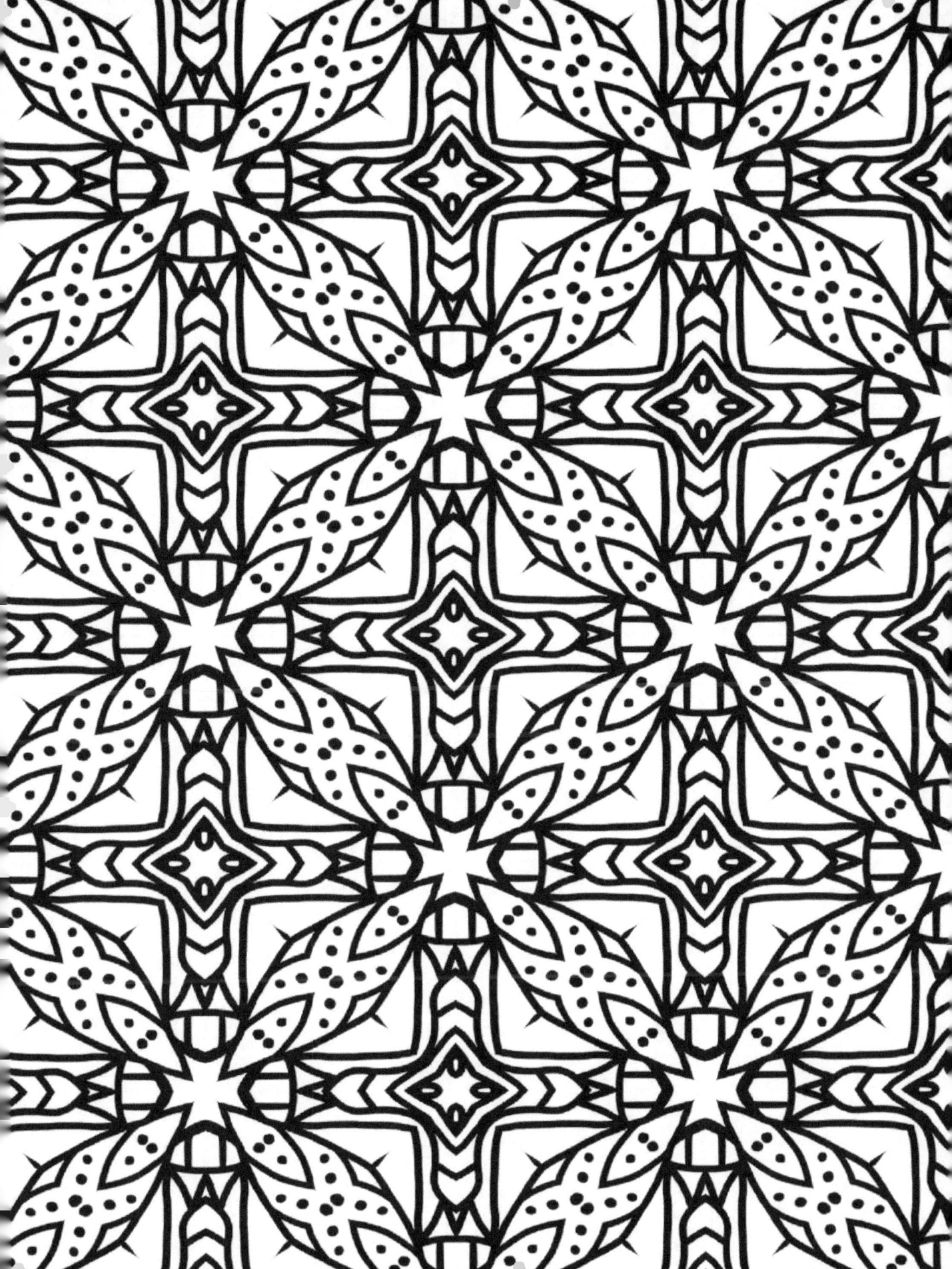

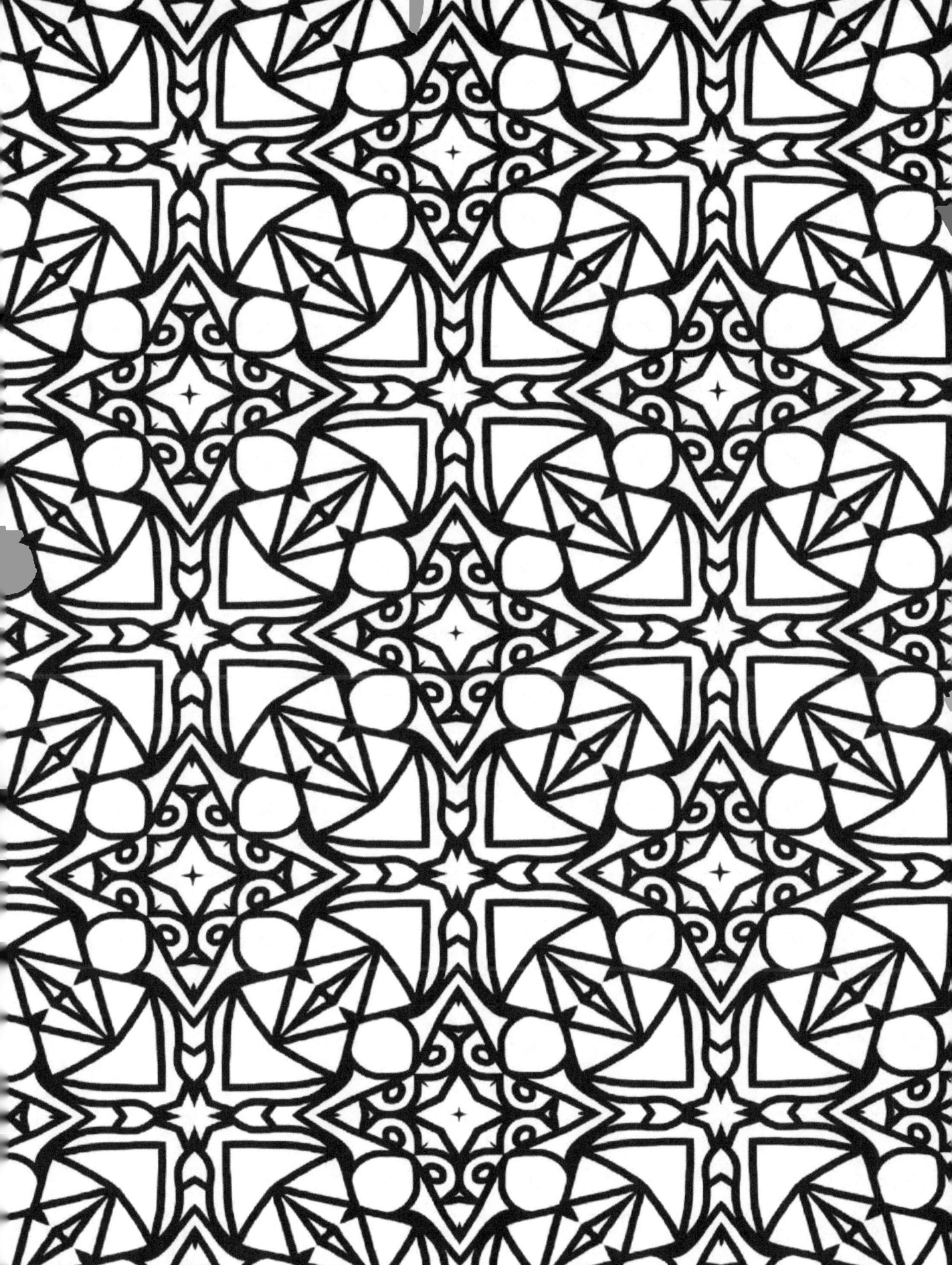

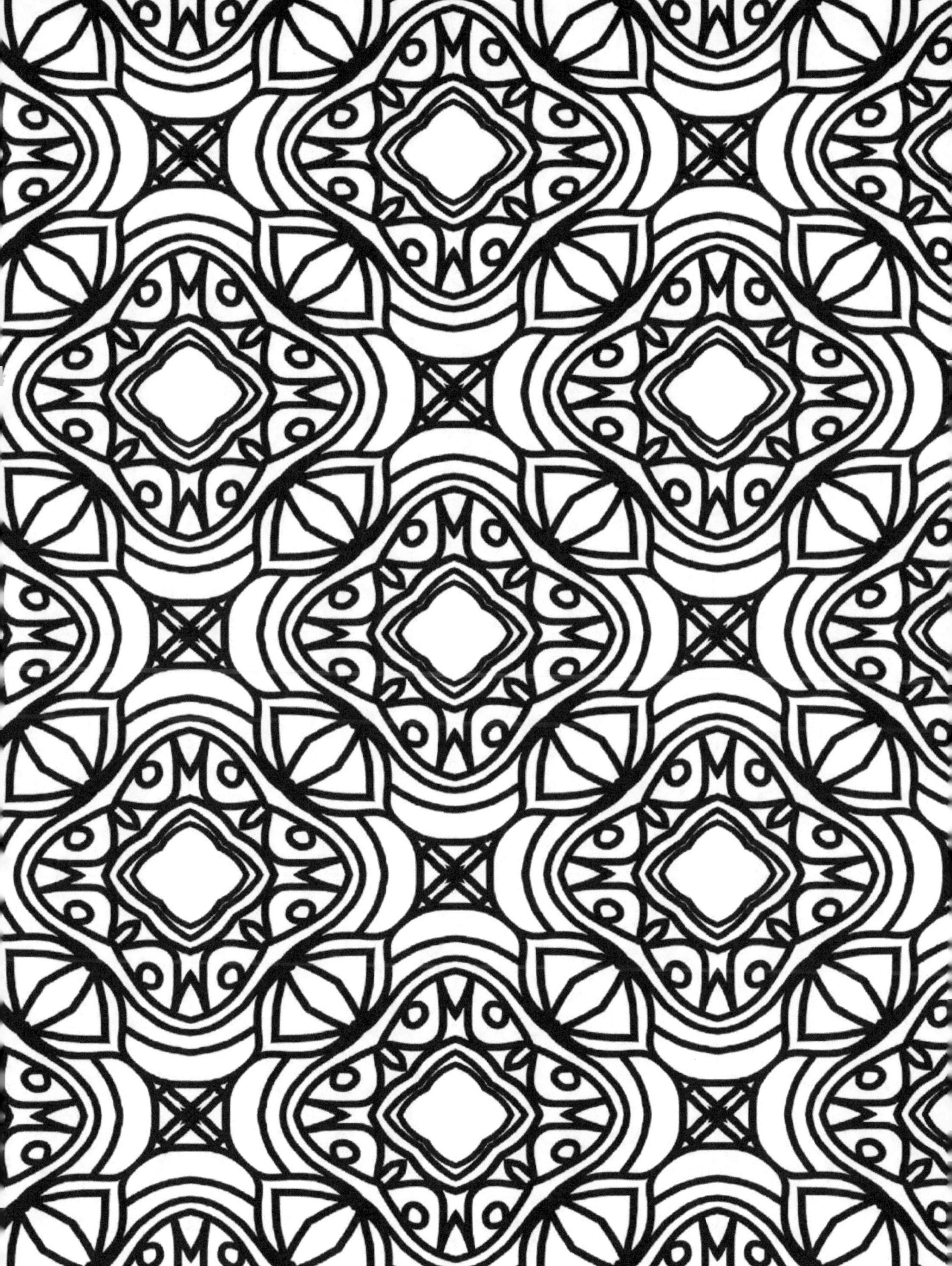

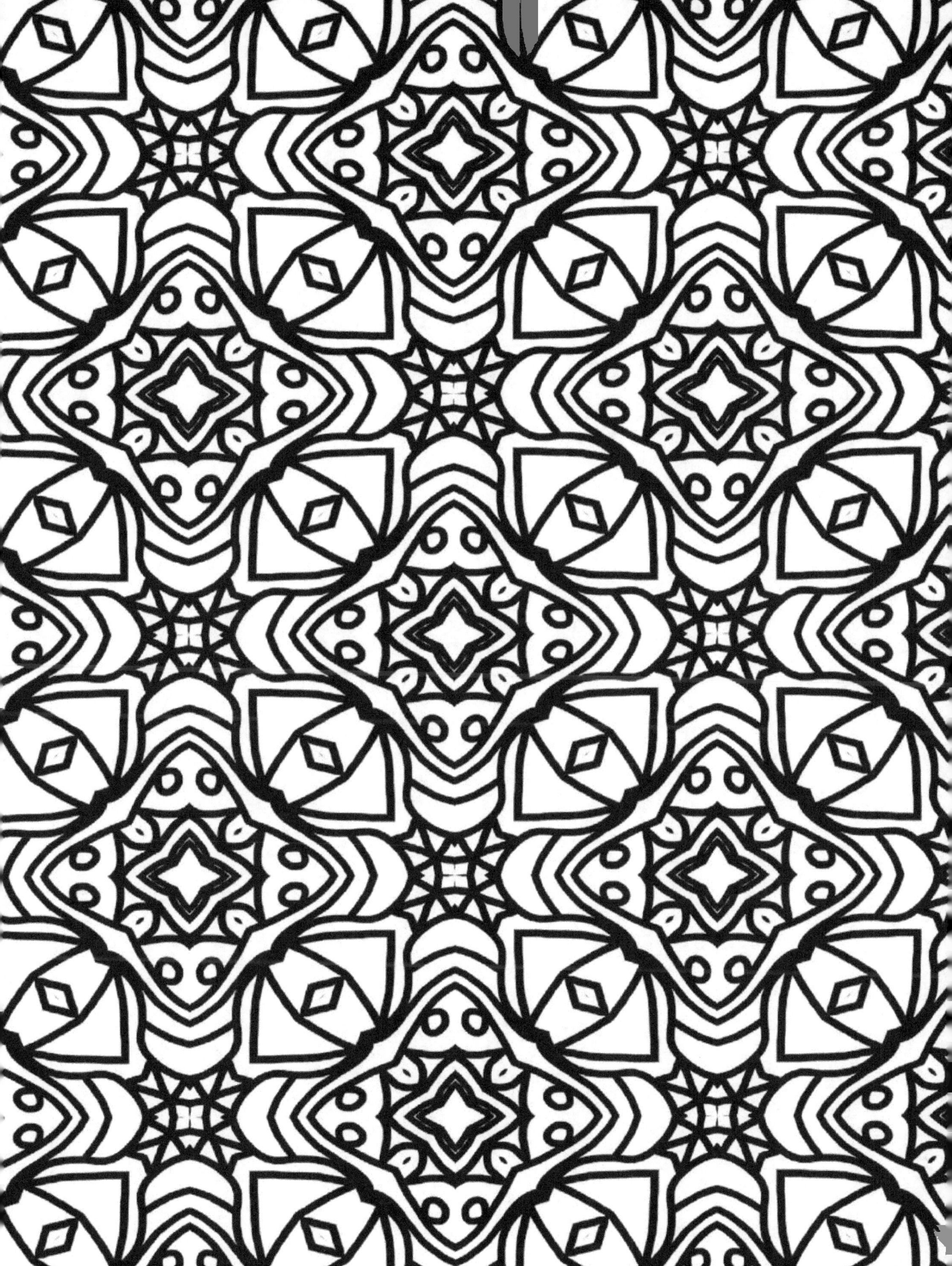

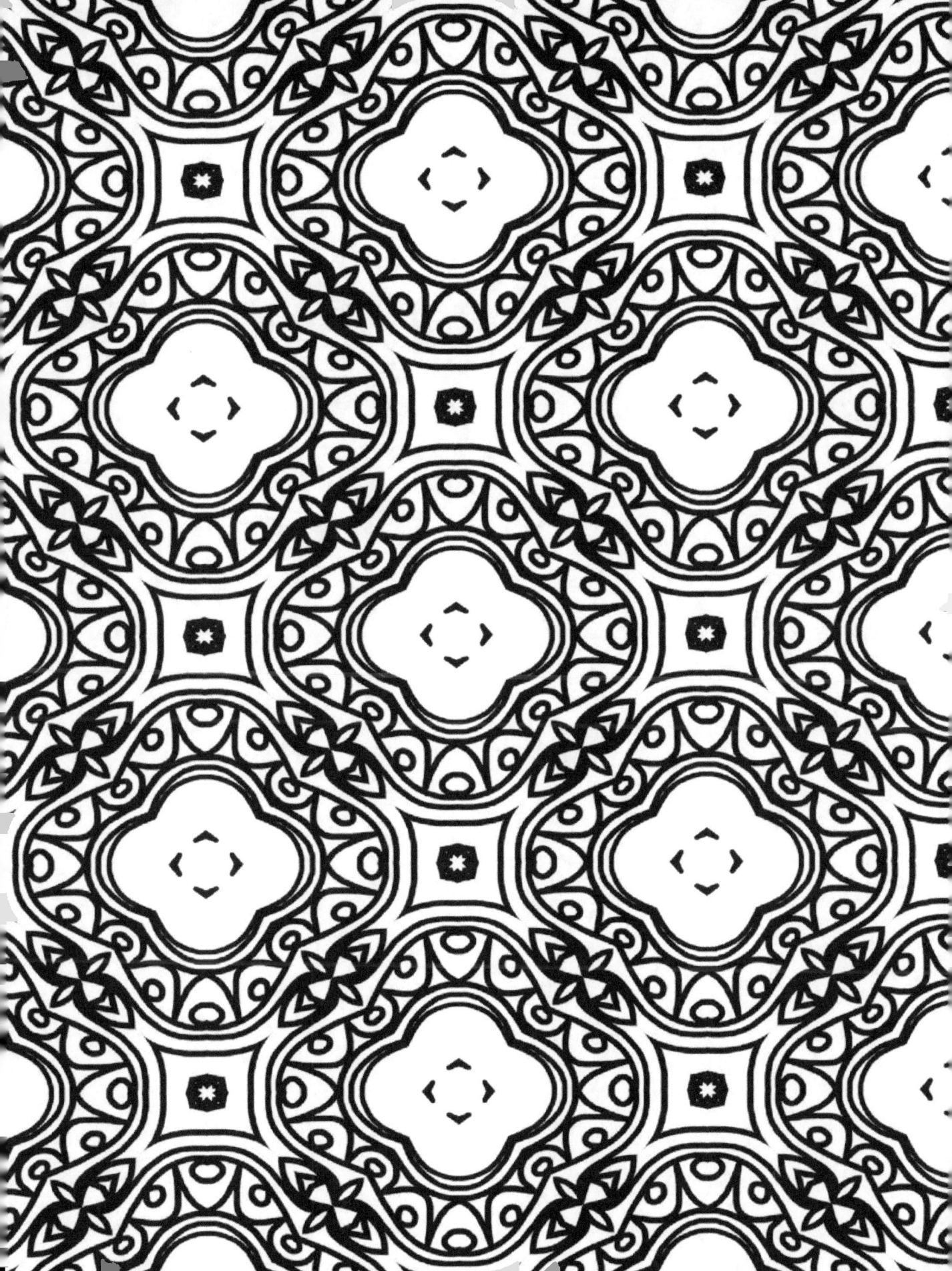

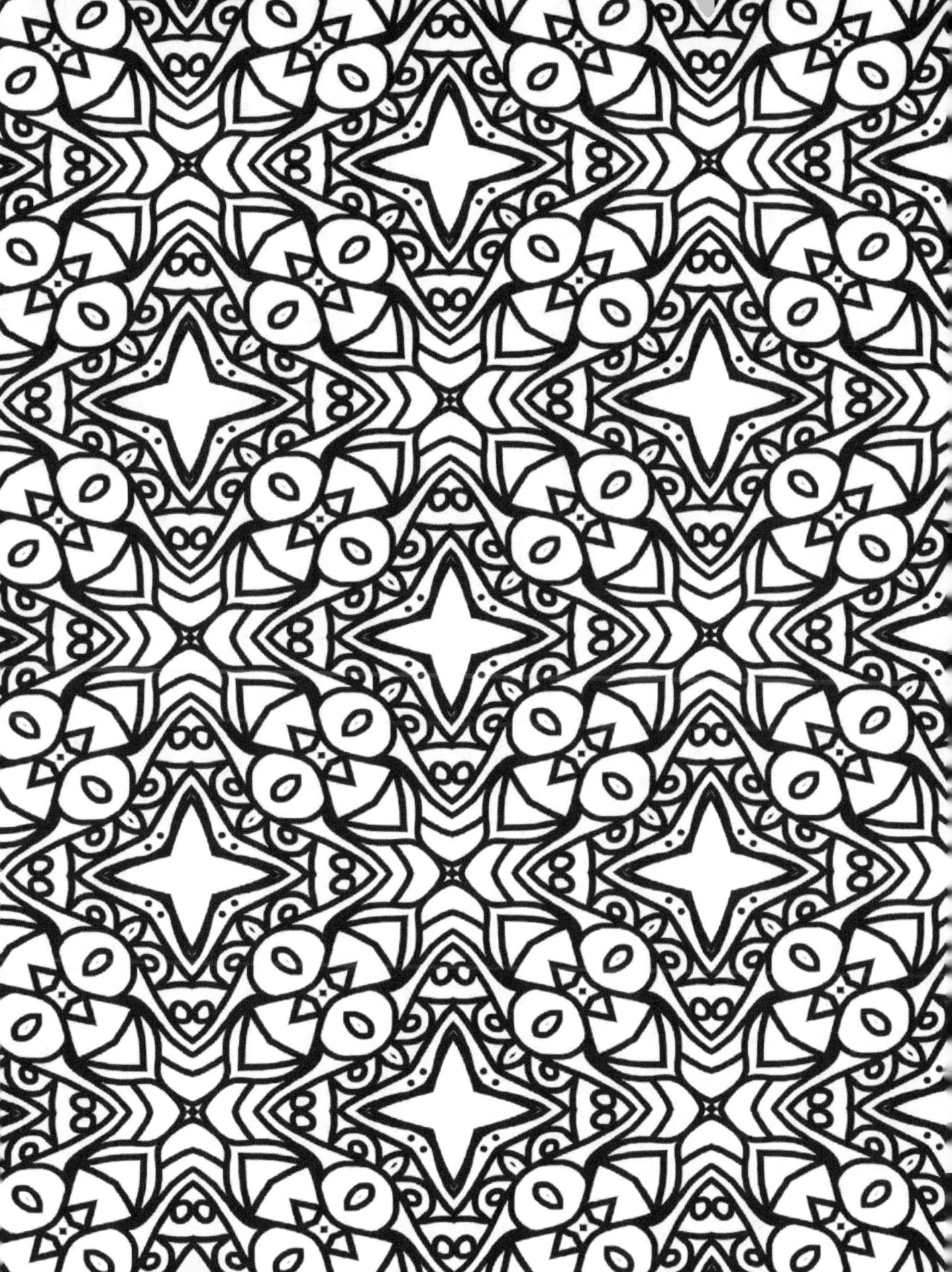

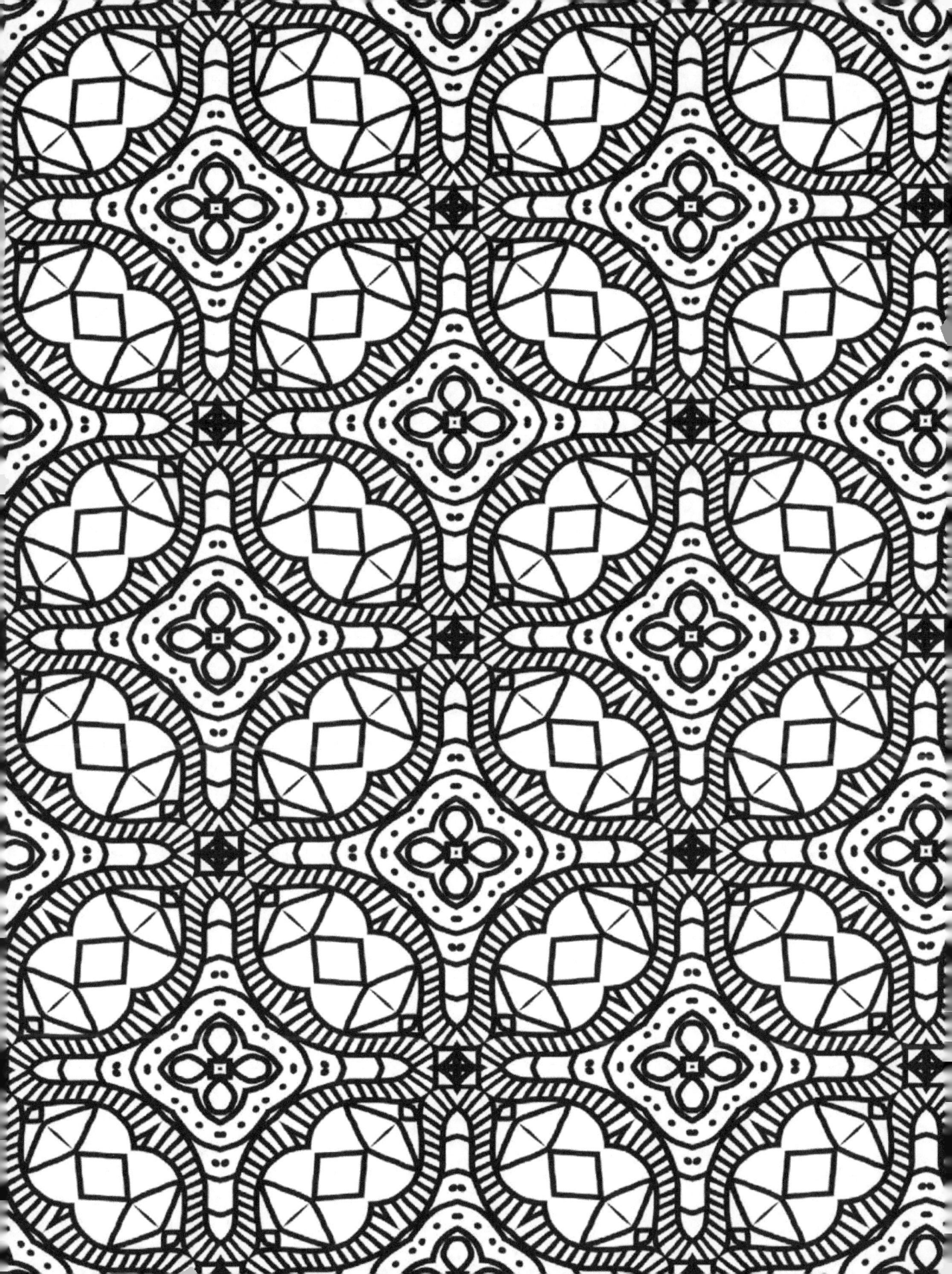